Calligraphy
Techniques and Uses

BY

Walter Foster Publishing, Inc.
430 West Sixth Street, Tustin, CA 92680-9990

Contents

Introduction

Calligraphy, the "art of beautiful writing," is very much alive and flourishing. This generation, driven by an innate need for individual self-expression, has revived a love and appreciation for the ancient art. How refreshing it is amid a plasticized and mechanized world. The nicest thing is that anybody can do it, EVEN YOU!

I like to think of this book as a "bridge" from the commonplace into an "adventureland" of intimate self-expression, beautifying your every artistic endeavor. Whether you are a beginner or an advanced calligrapher, this book encourages you to adapt, explore and be inventive in the practice of calligraphy. Within certain boundaries, there is freedom to make your needed practice both stimulating and rewarding. It is constant work of refinement, a never-ending training of manual skills. Yes, creative calligraphy has heart in it, it has the unique YOU in it! I hope this book with ample exercises can serve as a "bridge" to exciting new frontiers in your creative genius. As regular practice perfects your skill, you'll find it not only therapeutically enjoyable, but also profitable in the marketplace. Think of it as a link to other art forms.

Calligraphic lettering and design is an ideal companion to sketches, drawings, paintings, photography, lithography and silk screening. No matter where this adventure takes you ... into logos, business stationery, restaurant menus or t-shirts ... you can definitely end up "in the money" if you skillfully enhance your work with calligraphic versatility.

The impersonal world of today NEEDS your personal touch of "calligraphic charisma"; so, let your pen flow with feeling for this elegant communication; do the ancient masters proud and break into the frolicking variations of this enchanting art form. Now, with the imagination inspired and tools at hand let's cross the bridge and "go with the flow" to begin an adventure that is forever!

Materials

PENS

Calligraphy pens are specially made for this type of lettering. When used correctly, they control the thick and thin character of the letters. The nibs (or tips) come in a variety of sizes, from a very-fine point to a broad-edged point. The size of the nib determines the size of letter.

There are basically two types of pens: the "dip" pen, which must be dipped into ink; and the "fountain" pen, which has a self-contained ink supply that automatically feeds the ink. The fountain pen may be vacuum-filled or might contain an ink capsule. Both types come in a wide variety of sizes and brands. I prefer the convenience of the fountain pen--ready for use at all times.

Split nibs, steel brushes, and scribers are available for special effects. There are many fine, inexpensive felt pens on the market to practice with. (Pens made especially for left-handed people are also available.)

INK

Ink also falls into two basic categories: water-soluble and waterproof. The water-soluble ink is made for the fountain pen as it will not clog the pen. It may also be dipped from a bottle. Both types of ink are available in a variety of colors.

PAPER

The selection of paper is very important, depending on the quality and type of work that you do. For practice, art stores have stationery or "practice" paper tracing paper or layout bond). Paper with ruled lines or graph paper is also good to practice with. For final work, parchment paper, made specifically for calligraphy, is available. For a smooth look try hot-press illustration board, bristol board, or a fine bond paper. For a strong textured look try a paper with a pattern such as watercolor paper.

OTHER MATERIALS

Other useful materials are: a ruler, t-square, pencils, erasers, scissors, tape and paintbrushes.

Exercises

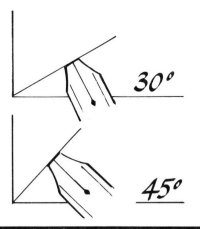

30°

45°

The key to beautiful writing lies in the angle the pen is held. This must be a CONSTANT angle, usually between 30 and 45 degrees to the horizontal lines on the paper. The angle is essential to achieve the "thick and thin" style of the letters.

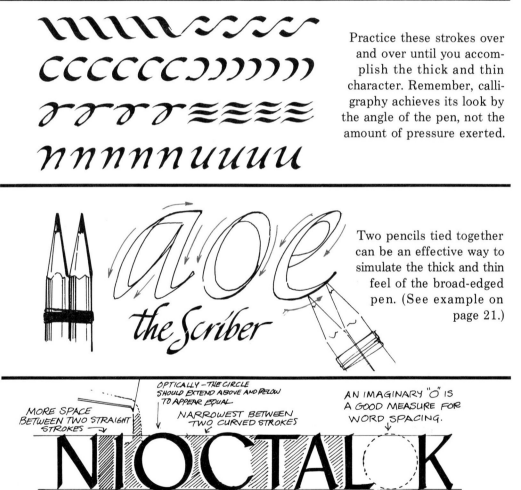

Practice these strokes over and over until you accomplish the thick and thin character. Remember, calligraphy achieves its look by the angle of the pen, not the amount of pressure exerted.

the Scriber

Two pencils tied together can be an effective way to simulate the thick and thin feel of the broad-edged pen. (See example on page 21.)

OPTICALLY – THE CIRCLE
SHOULD EXTEND ABOVE AND BELOW
TO APPEAR EQUAL

MORE SPACE
BETWEEN TWO STRAIGHT
STROKES

NARROWEST BETWEEN
TWO CURVED STROKES

AN IMAGINARY "O" IS
A GOOD MEASURE FOR
WORD SPACING.

NIOCTALOK

Proper letter and word spacing is critical for legibility and the texture of the written page. There are a few rules of thumb in spacing, but the calligrapher must make continual optical adjustments. Generally, all spaces should contain an equal amount of "liquid" (space). Note where compensations should be made.

UNCIAL

Uncial is a handwriting used especially in Greek and Latin manuscripts of the fourth to the ninth centuries. They are made with somewhat rounded, separated majuscules but have cursive forms for some letters. They are used quite often, having gained popularity because of their beauty.

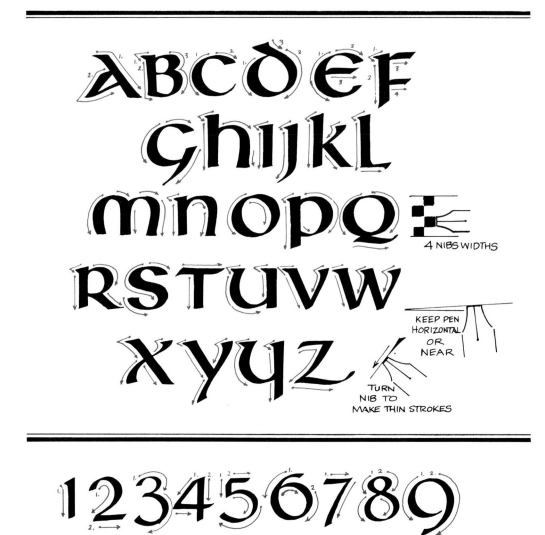

Black Letter

Black Letter is a heavy, angular style, developed during the eleventh century in Northern Europe for use in the knightly courts. The lower case letters are based on a rectangular "o" while the capitals are circular in form.

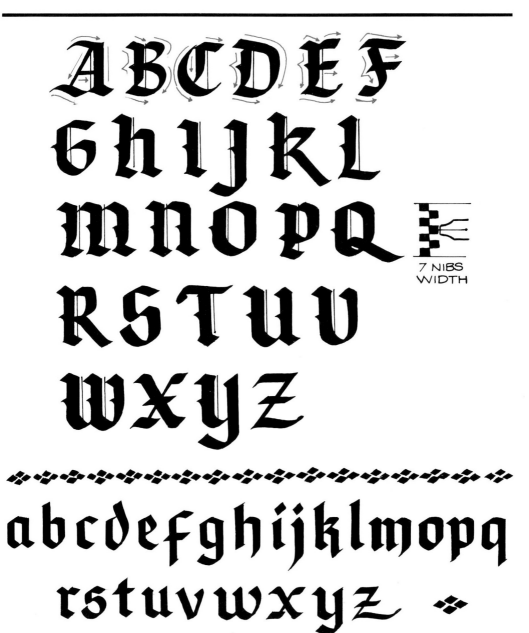

7 NIBS WIDTH

Chancery

In the sixteenth century, Renaissance Italy gave birth to this beautiful, formal italic bookhand and handwriting style. It is a favorite of todays calligraphers because of its less serious, free-flowing nature.

A B C D E F G

H I J K L M N

O P Q R S T U

V W X Y Z

majuscules
(upper case)

Caps 8 pen widths high

45° ANGLE TO LINE OF WRITING

small letters 5 widths of pen high

ascenders 5 pen widths above

descenders 5 pen widths below

AB *abcg*

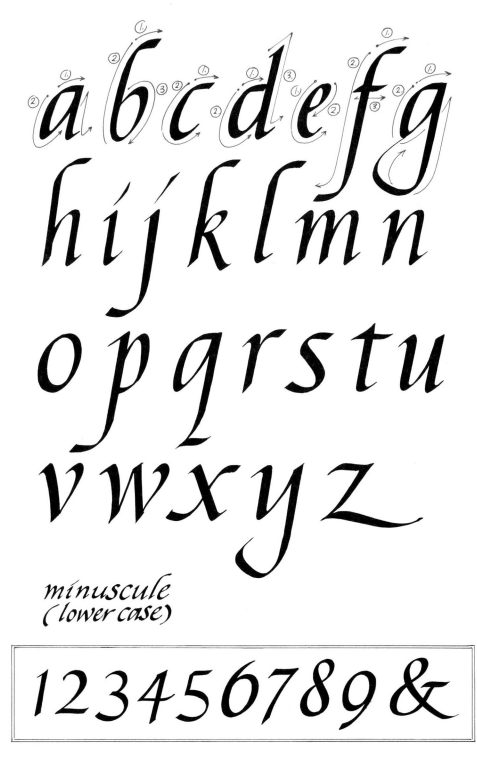

minuscule
(lower case)

1 2 3 4 5 6 7 8 9 &

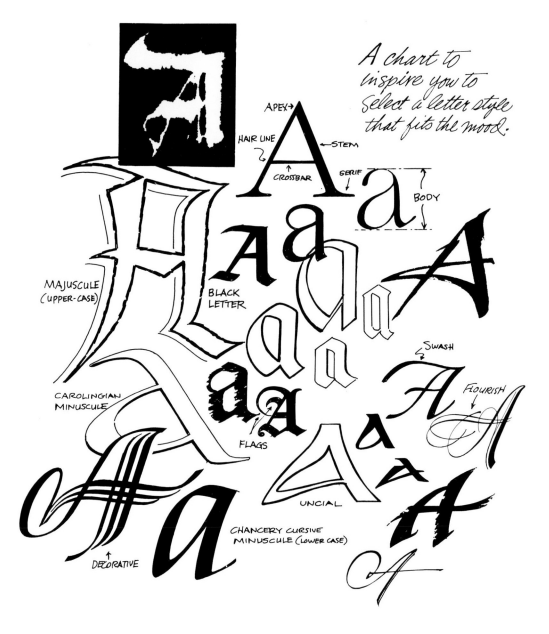

A chart to inspire you to select a letter style that fits the mood.

APEX→

HAIR LINE

←STEM

CROSSBAR

SERIF

BODY

MAJUSCULE (UPPER-CASE)

BLACK LETTER

CAROLINGIAN MINUSCULE

SWASH

FLOURISH

FLAGS

UNCIAL

CHANCERY CURSIVE MINUSCULE (LOWER CASE)

DECORATIVE

Variations on "A" theme

Design

Good lettering design emphasizes important words, creates interest and expresses the proper mood and feeling. This is achieved through contrasts of size, weight, form, direction, color and texture.

Study the following pages to see how you can use multiples of these contrasts to create unique, original designs that complement the nature of the text.

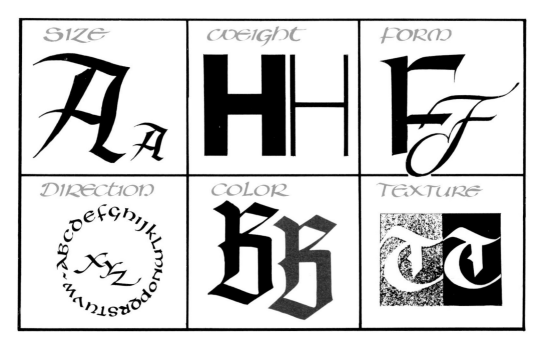

MULTIPLYING THE CONTRASTS

CONTRAST OF...
SIZE

Contrasts of size are used when import and impact are needed. Consider the attention-getting 144 point headlines of a newspaper. They are complemented by the presence of the smaller copy underneath. It is this contrast that helps the eye to sort out the order of importance and assimilate the message.

Study the expert use of size contrasts in advertisements, magazines and books. Use them in your own designs to draw attention to the subject and to emphasize important words.

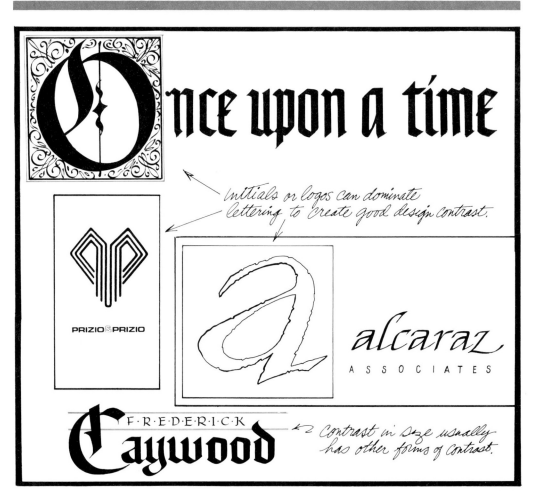

Once upon a time

Initials or logos can dominate lettering to create good design contrast.

PRIZIO & PRIZIO

alcaraz
A S S O C I A T E S

F·R·E·D·E·R·I·C·K
Caywood

Contrast in size usually has other forms of contrast.

WEIGHT

Weight is comparable to size, but refers to the thinness or thickness of the strokes rather than the height and width of the entire form. In typography thick letters are called "heavy" and thin letters called "light." Contrast of weight is a dramatic way to create interest. Its visual appeal can emphasize a key word, title or feeling. It is often used with other kinds of contrast, such as size, color or form.

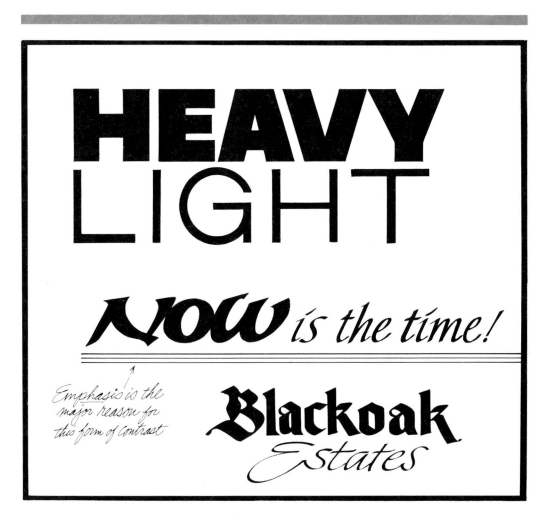

FORM

Form refers to the shape of a letter. It might be constructed of straight lines or curved lines, thick lines or thin lines. They might be square, round or triangular; fancy or plain. Letterforms have a characteristic beauty of contrast that helps us to visualize special meanings. Some styles create a soft, graceful, peaceful feeling; while others are strong, bold and dignified. Choosing the correct letterform to suggest a particular mood is critical. Often, contrast can be achieved by combining compatible letter styles such as Black Letter capitals with lower case Uncials, or Roman with italics. Contrast of form can be used to emphasize a certain word, initial, heading, or logo.

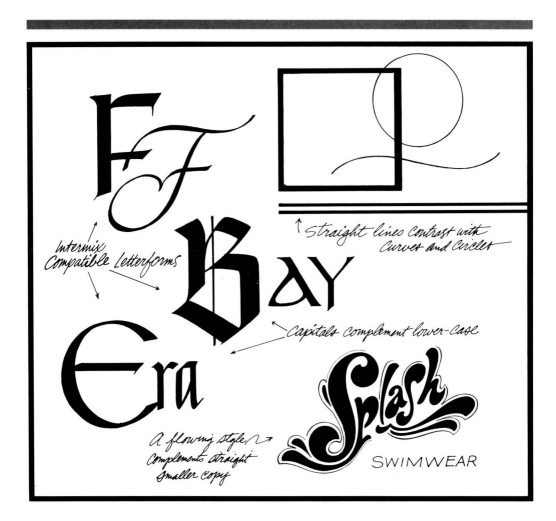

DIRECTION

We are accustomed to reading and writing in a horizontal direction. Horizontal lines create a peaceful feeling, like the horizon line of a beautiful sunset. Straight lines are easily balanced and restful.

Sometimes we need to disturb this peace and gain attention by creating contrast. We can lean, turn, tilt or curve lines to project the movement a subject calls for.

A cursive letter or script provides a forward movement. Vertical lines make things seem taller while horizontal lines make them seem longer. Intersecting lines create tension, become dynamic or cause confusion. Skillful use of your "sense of direction" creates movement to focus attention on your designs.

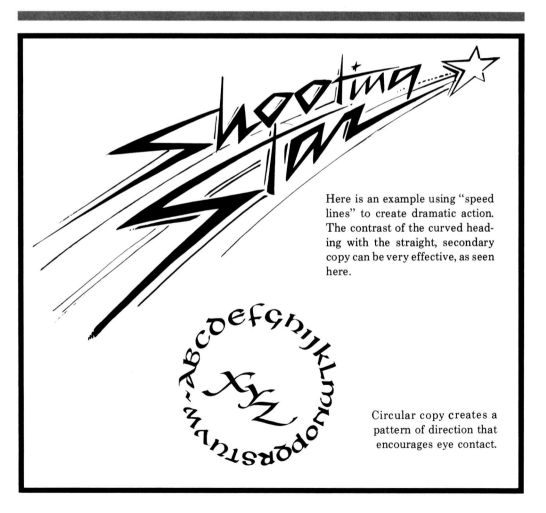

Here is an example using "speed lines" to create dramatic action. The contrast of the curved heading with the straight, secondary copy can be very effective, as seen here.

Circular copy creates a pattern of direction that encourages eye contact.

COLOR

Color is one of the easiest ways to create interest and to emphasize. It is perfect for expressing the mood of a subject as it can extend a variety of feelings.

Warm colors such as red, yellow and orange attract the eye. They jump out at you and make you take notice. Warm colors indicate action, heat, danger, sunshine, excitement or alarm. A small amount of red will capture the reader as it flames forward, burning up the page, but don't overdo it! A small amount will go a long way. (See examples on pages 11 and 54.)

Cool colors like blue and green recede, making words appear farther away. They convey feelings of calm, cold, loneliness, peace and melancholy. To create impact with cool colors, use larger areas of color, such as an entire background.

Choose colors that complement the nature and mood of the subject. If a job calls for a single color, black is not always the best choice. Try burgundy, brown or gray. Note how color enhances the mood and spirit of the words on the next page.

Red flames forward and can be effective even when used sparingly

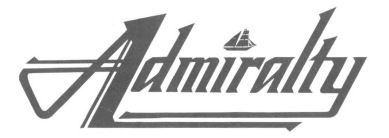

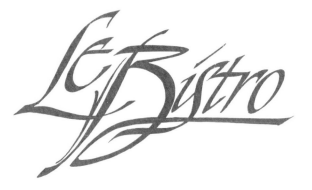

TEXTURE

Texture is used to create interest and to bring out a desired mood. There are many ways to gain contrasts of texture; the most obvious is to use a textured lettering surface such as a watercolor or parchment paper. The rough-textured paper absorbs less ink than smooth papers, creating a ragged appearance.

Film screens of dots, lines and other patterns can be laminated over the lettering to create visual texture. (Art supply stores have many varieties available.) Writing on tracing paper placed over pebbled board, sandpaper, or wood produces interesting effects. Often, the letterform itself creates a pattern of texture.

Add the excitement of texture to a word, letter or the surrounding areas and the page will suddenly take on character, interest, and mood.

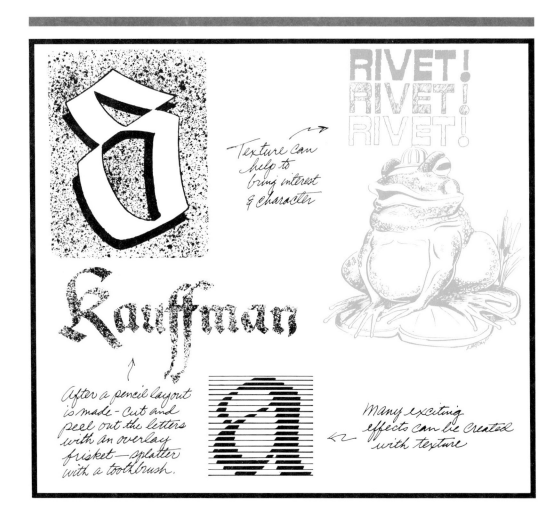

Texture can help to bring interest & character

RIVET!
RIVET!
RIVET!

Kauffman

After a pencil layout is made - cut and peel out the letters with an overlay frisket — splatter with a toothbrush.

Many exciting effects can be created with texture

18

Developing a concept

Many people have the skill to create wonderful designs, but often don't know where to begin. Here is a hypothetical assignment for a special heading: "A taste of honey."

First, find out all the necessary information. Who or what is it for? Where, when and how will it be used? Next, mentally analyze the subject. What mood best fits? What letterform will best convey that mood? How can you create interest? Then, do some small "idea sketches." These should take on meaning and lead to the final development of the finished work.

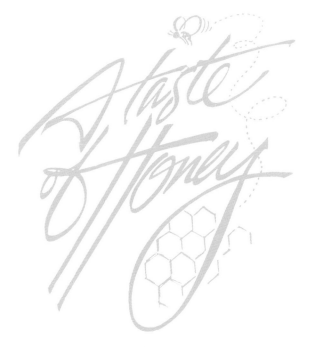

The final product.

Techniques...

The ANTIQUE LOOK

Special antique effects can be accomplished with penwork on a rough-textured paper, or, as in this case, by carefully drawing the letters, inking in, then thumb-flipping tempera from a toothbrush onto the letters to create the appearance of age.

Use this technique to add texture and to create a mood.

the famous scriber → Sketch the letters in pencil first...

Outline with mechanical or fine point pen — edges should be uneven

Fill in with a broad pen or brush (waterproof Black ink for reproduction)

To give it a further touch of antiquity spray it with a toothbrush using opaque white paint

Village Woods

Plaza Inn

the Woodcut Look

With its antique charm and beauty, you can produce this old world woodcut look with a minimal amount of time and effort. It looks great with certain subjects and can set off an important thought or title. If the mood is right it can be very effective for a special attention-getting logo or heading.

1. Trace the design from a vellum onto double-thick illustration board. Pencil it carefully.

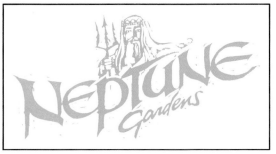

2. Paint the entire background with white tempera or a colored water-soluble paint.

3. Allow to dry thoroughly, then flood it with a waterproof ink (use black if it is to be photographed).

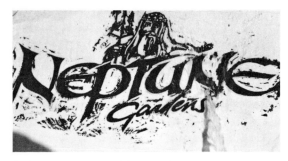

4. After the ink dries, wash off the tempera with a spray of water. Touch up unwanted areas with white paint for the final design.

5. It is now ready to reduce or enlarge and print in any color you wish.

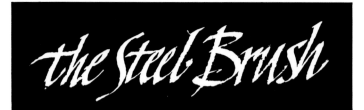

the Steel Brush

Carmel by the Sea

Try the steel brush, with a practiced hand it can do wonders! They are excellent for larger show card work because of their wider sizes. If, for reproduction work, you wish to have a strong-textured "feel" use it on rough watercolor paper. However, nice effects can also be achieved on smooth paper. Experiment with different types of paper, the results will amaze you! A good way to get that special look is to do the words several times each, then cut and paste the best letters together. Note: the steel brush can only move forward or it will splatter.

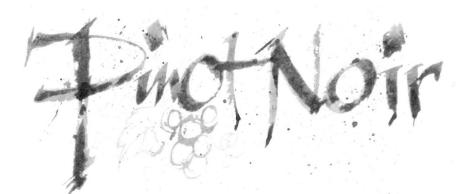

This was executed with the steel brush on rough-textured watercolor paper using sepia ink. Additional texture was added by splattering with a toothbrush.

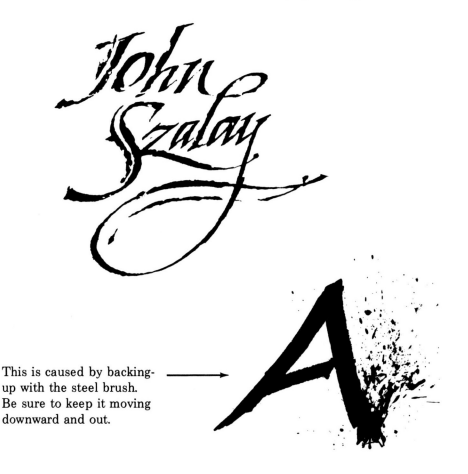

This is caused by backing-up with the steel brush. Be sure to keep it moving downward and out.

Dry Brush

"Dry Brush" is a technique wherein a regular lettering brush is used with pigments in a moist, not wet, state. The amount of thinner used depends on the material you are writing on. You use more thinner for a rough-textured, porous paper than for a hot press, smooth surface. You will discover the proper consistencies by trial and error.

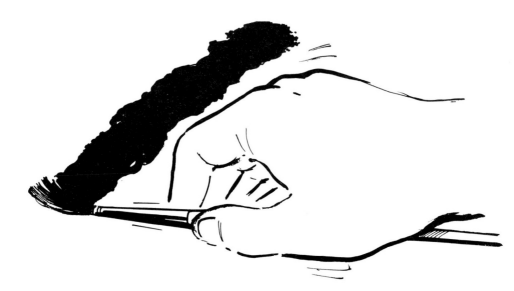

Hold the brush almost parallel to the drawing surface, as shown, then drag the brush sideways to create each letter. The subsequent loss of control creates interesting and often exciting effects.

This technique requires a vast knowledge of letter styles and MUCH practice to master, but the finished product can be worth the extra effort.

The dry brush is a difficult technique. It is usually a "happy accident" when one or more letters come out exactly as you had intended. I normally letter each design several times, then cut and paste the best parts together as shown below. Retouch, if necessary, with opaque white for the final piece.

This heading was lettered several times, then assembled from the best parts.

The cut marks do not show on the final, printed art.

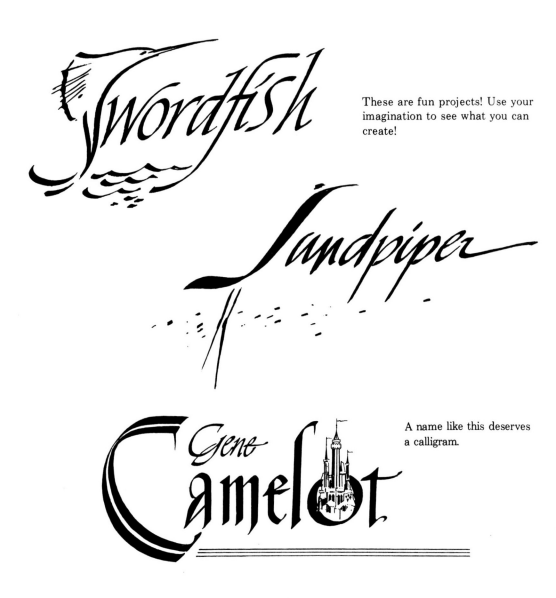

Calligrams

A "calligram" is a word in which a picture is created out of one or more of the letters to illustrate the subject or meaning of the word itself. A great deal of creativity is needed to use this technique, but the result is well worth the effort.

These are fun projects! Use your imagination to see what you can create!

A name like this deserves a calligram.

Technically, these are not calligrams, but the pictorial images add similar visual appeal.

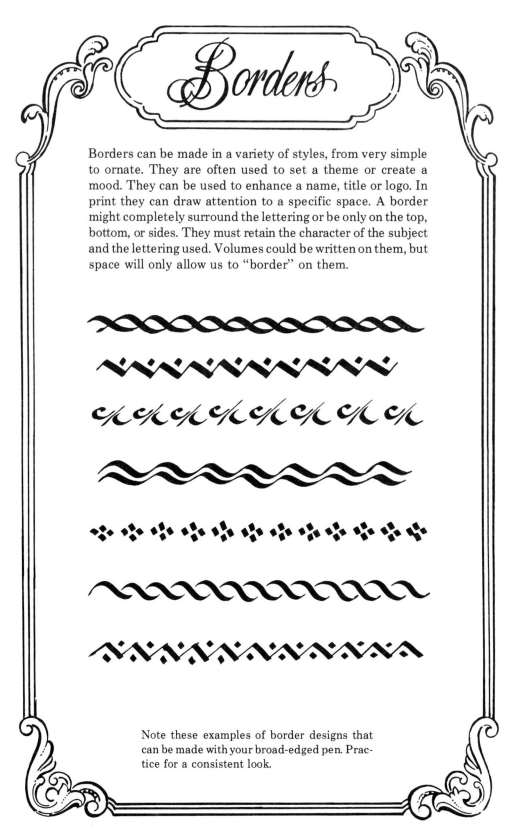

Borders

Borders can be made in a variety of styles, from very simple to ornate. They are often used to set a theme or create a mood. They can be used to enhance a name, title or logo. In print they can draw attention to a specific space. A border might completely surround the lettering or be only on the top, bottom, or sides. They must retain the character of the subject and the lettering used. Volumes could be written on them, but space will only allow us to "border" on them.

Note these examples of border designs that can be made with your broad-edged pen. Practice for a consistent look.

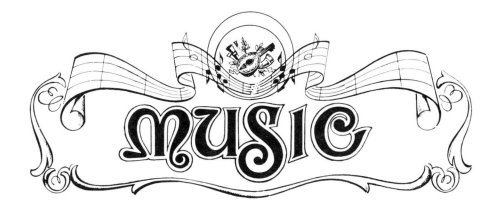

Music

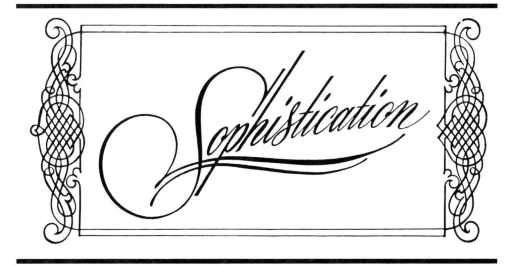

Sophistication

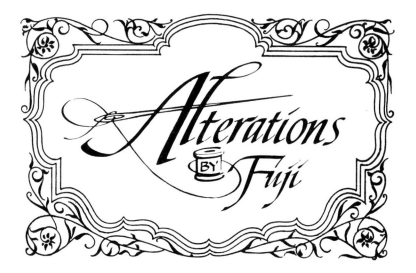

Alterations by Fuji

MIRROR IMAGES

A unique method of design is to make the mirror image of a word or letter. They can be "mirrored" back-to-back, face-to-face, or at the bottom (as above). The beauty of balance and form creates an example of indelible impression. Emblemize the reflection of quality and character through mirror images. It's "doubly delightful."

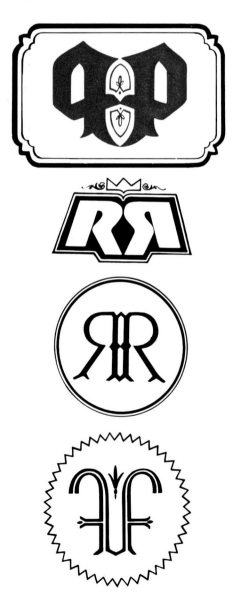

Black Letter (or Gothic) initials have a regal appearance.

Here, the letters are reversed out of the solid background. This works best with heavy letters.

The circle complements the relatively straight strokes of the letters. Use a fine pen and an ink compass to draw circles.

The heavier letters are complemented by the fine line of the outline.

Flourishes

Flourishes can balance a design and emphasize the flow of a line. They can help to relate the mood and feeling of the subject. Flourishes can direct attention to a heading or caption, or simply decorate the margin, word or words.

As you practice and become proficient in calligraphy, you will develop your own style. Flourishes will be a part of that style.

C'est SiBon

Filigree, flow and extra lines must be drawn carefully in order to retain readability. In the example above, the extra lines are thinner to keep from destroying the letterform.

Spicy

A fine-point pen and a toothbrush were used to add texture to this design. These flourishes create the visual look of spice.

USES of Calligraphy

Calligraphy can be used anywhere handwriting is used. It is also often used in place of typography. It is a valuable skill that potential customers are unable to perform; they appreciate your talent and are willing to pay for it.

There are many commercial applications for calligraphy including: album jackets, signs, award certificates, calendars, labels and packaging, and advertisements.

The following pages are devoted to other possible uses. I hope they will stimulate your thinking and spark your interest toward finding your place in the modern revival of calligraphy.

POST CARDS

Decorative lettering is frequently used to enhance postcards. Appropriate styles and techniques will provide the perfect combination of picture and prose.

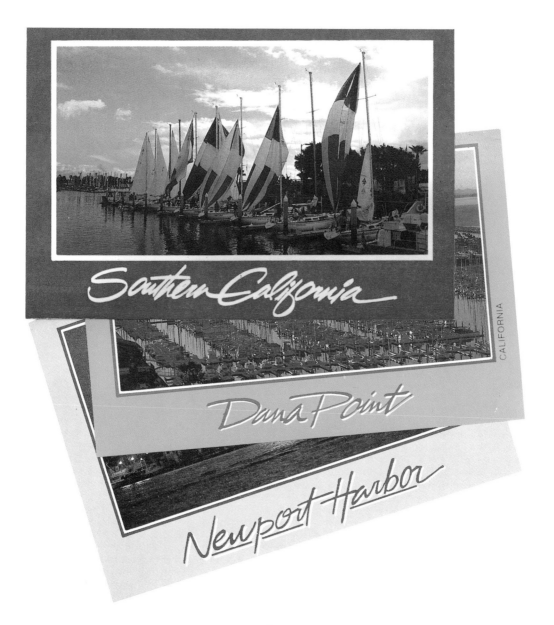

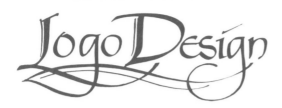

Logo Design

Logo - *The name of a company or product in a special design used as a trademark in advertising.*

Every day we identify, accept and buy on the basis of logo design.

In today's world there is a growing number of products all competing for our attention, struggling to be seen and heard. Happily, this provides a great deal of work for the calligrapher, as calligraphy can often provide the correct mood and spirit of the needed logo.

There are many details to consider when designing a logo. Who or what is the logo for? What kind of image and mood does the customer want to project? Where is the logo to be used? What type of audience are they trying to reach?

These are some of the things you must keep in mind when designing a logo. Use texture, size, weight, form, color, and direction to express the proper feeling.

The value of a logo cannot be overestimated. Use your imagination to create exciting, distinctive and successful designs.

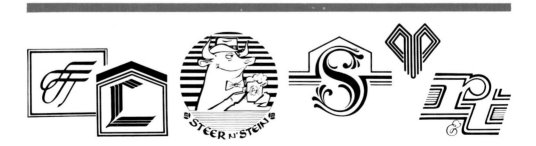

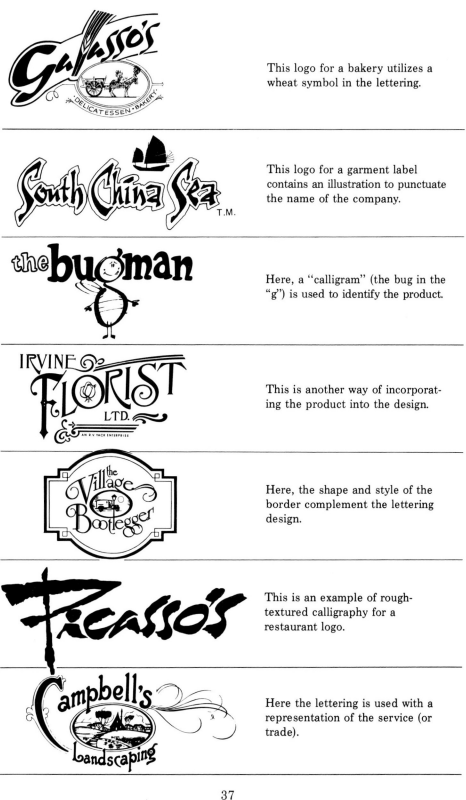

This logo for a bakery utilizes a wheat symbol in the lettering.

This logo for a garment label contains an illustration to punctuate the name of the company.

Here, a "calligram" (the bug in the "g") is used to identify the product.

This is another way of incorporating the product into the design.

Here, the shape and style of the border complement the lettering design.

This is an example of rough-textured calligraphy for a restaurant logo.

Here the lettering is used with a representation of the service (or trade).

Signatures

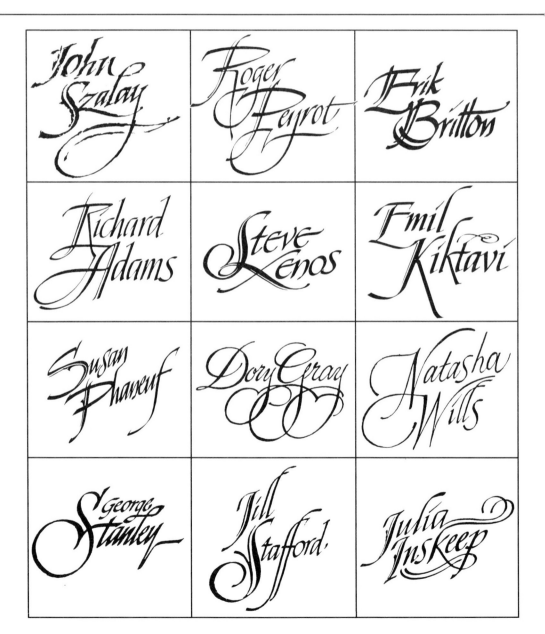

Signatures are a fun and profitable way to experiment with calligraphy. Practice writing the names of friends, family and business associates. Try to capture their spirit and personality by using a variety of pens and brushes to achieve different effects. This also gives you a chance to try swashes, flourishes and decorative lettering. Be creative and impress your friends with their own calligraphically designed signature.

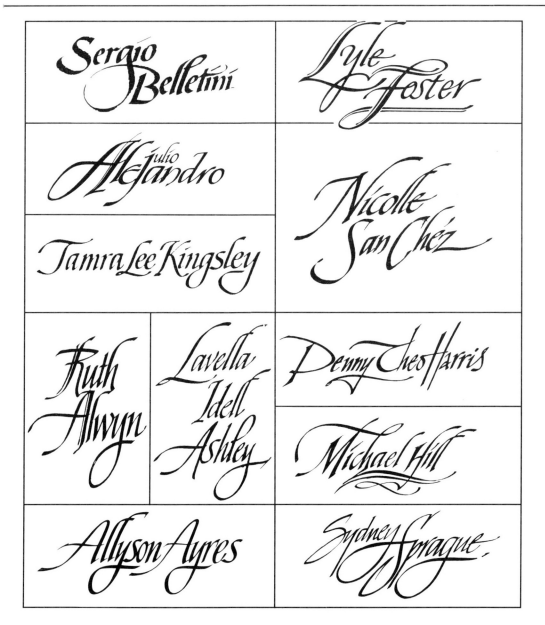

Many professionals such as doctors, lawyers, business executives, artists, photographers, politicians, engineers, and advertising specialists like to use decorative signatures. A person's name, specially designed in calligraphy, can be their best advertisement. Their many practical uses include: personalized stationery, memo pads, rubber stamps; name plates for automobiles, office door, or desk; business and personal cards; fabric monograms for shirts, handkerchiefs, socks, golf club bags, and tote bags; leather monograms for briefcases, portfolios, billfolds, desk sets, and flask holders; metal engravings for watches, rings, silver, and pens; and, perhaps one of the most important, product labels and package design carrying just the calligraphic name. A creatively designed name can make all the difference!

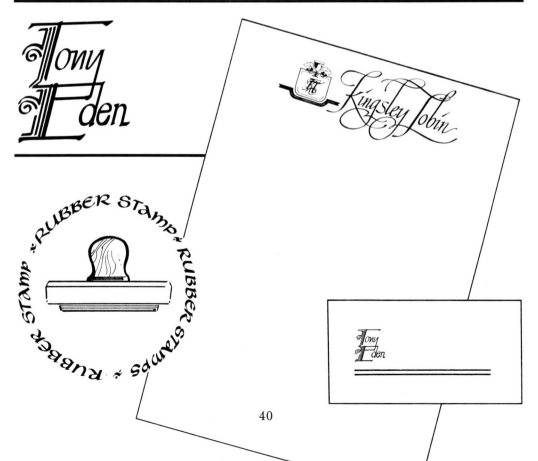

Monograms

Monograms flow, creating an elegant, prestigious mark for their owner. They can be put on glasses, towels and stationery. They make a personalized statement of elegance. They can become a personal trademark or logo. They are certainly a unique gift for graduates and newlyweds! Note examples of how letters can flow together to create a personal identity with grace and harmony.

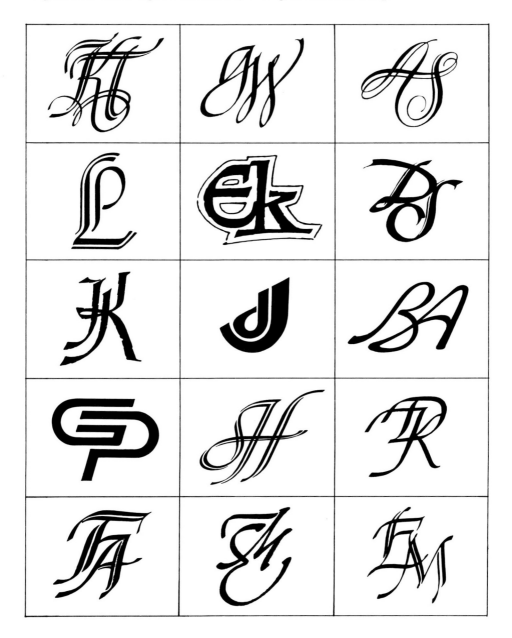

Book Plates

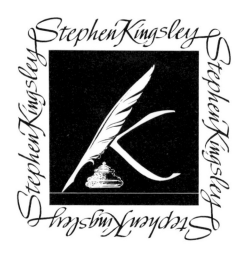

A bookplate is a book owner's identification label that is usually pasted to the inside front cover of a book.

Ex Libris is Latin for " from the library of." This is normally followed by the name of the individual on a bookplate.

What greater gift could a bibliophile (lover of books) receive than a well-designed, personalized bookplate? The creative possibilities are endless. Consider their interests, name and personality when designing it. Use monogram initials, a special logo, a symbol, shield, crest, coat of arms, et cetera. The possibilities are limited only by our own "ink"-linations.

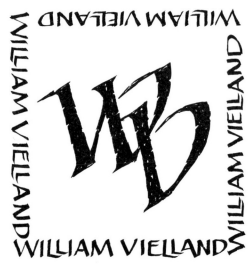

EX LIBRIS

Robin

LYLE FOSTER
Ex Libris

KE
Ken Enright

43

Book Jackets

William Shakespeare
Othello

Designing a book jacket requires careful study as to the mood and subject. For example, a children's book needs a much different lettering style than a science fiction or romance novel. The proper lettering, often tied with an illustration, can be responsible for attracting and holding the interest of a prospective reader.

A book is often judged by its cover; calligraphy sets the mood as no other lettering form can.

Oliver Twist

Charles Dickens

T-Shirts

Printed t-shirts are big business these days, creating a great demand for lettering and design. T-shirts reflect the ever-changing mood of the day. It might be skateboarding and advertising slogans one day, cartoon characters and musical groups the next. Try to keep up with the latest trends and adapt your lettering styles as needed.

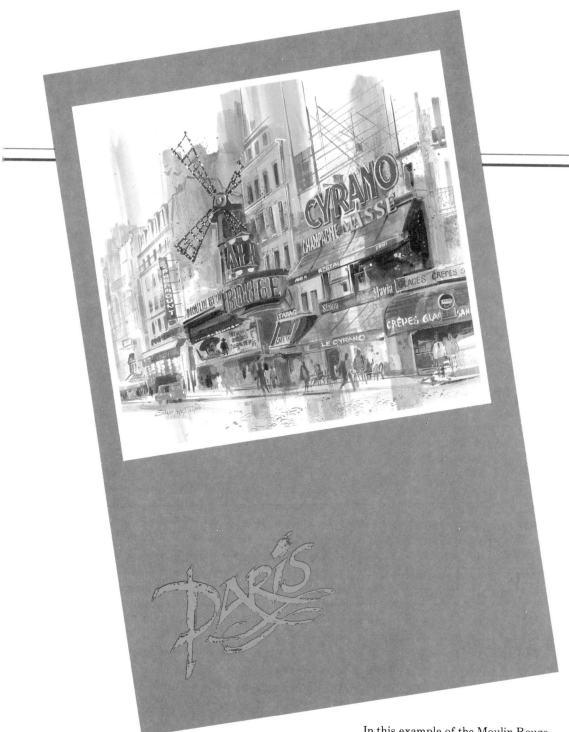

In this example of the Moulin Rouge in Paris, the lettering was done with a steel brush on rough-textured water-color paper.

POSTERS

There are two separate markets for posters. One is for advertising, the other is for interior design. Both markets utilize hand-lettering to enhance the art and create the proper feelings of mood and rhythm.

Originally, posters were used as an advertising medium. With their unique combination of image and message, they had a visual impact other print media lacked.

It is believed that in 1867 Frenchman Jules Cheret became "father" to the modern-day poster when he turned out the first successful marriage of word and image. One of Cheret's contemporaries and followers was Henri de Toulouse-Lautrec. How appropriate then, that the poster shown left sites the famous Moulin Rouge where Toulouse-Lautrec first sketched the club's dancing girls on the tablecloths. These were later hung outside as advertisements; one of the first commercial uses of the poster.

In the 1960's pop artists, such as Andy Warhol, treated the poster as an art form. The general public eventually came to see them as such. They have become a popular, dynamic, and inexpensive wall decoration used everywhere—from offices and restaurants to homes and college dorms.

Whether a poster is used for advertisement or interior decoration, it must catch the eye of the viewer and get its message across quickly. This is most effectively accomplished with calligraphic lettering, which creates an identity for both artist and subject.

Menu
DESIGN

An appetizing menu requires a "subtle sell." Flowing, gentle, graceful lines suggest a pleasant meal.

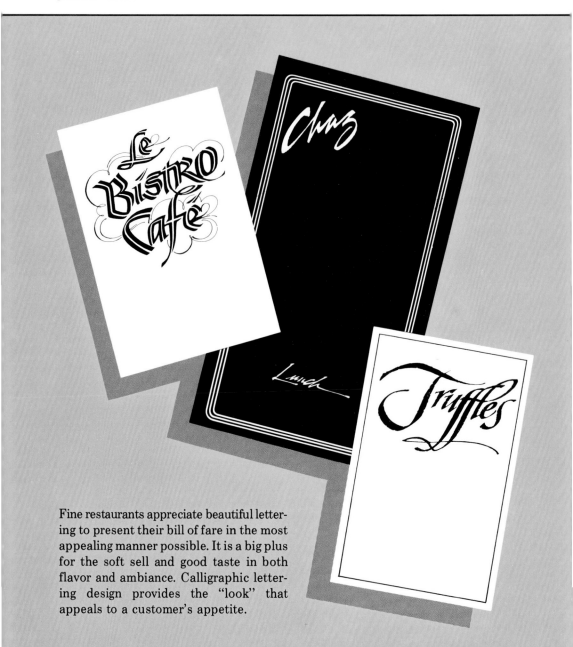

Fine restaurants appreciate beautiful lettering to present their bill of fare in the most appealing manner possible. It is a big plus for the soft sell and good taste in both flavor and ambiance. Calligraphic lettering design provides the "look" that appeals to a customer's appetite.

From the "Early Bird" to the "Night Owl" special, bored customers sit and perch their elbows on the table. What they need is the attention-getting power of a calligraphically-enhanced table tent to keep them occupied. Its suggestive selling power is great in these defenseless moments.

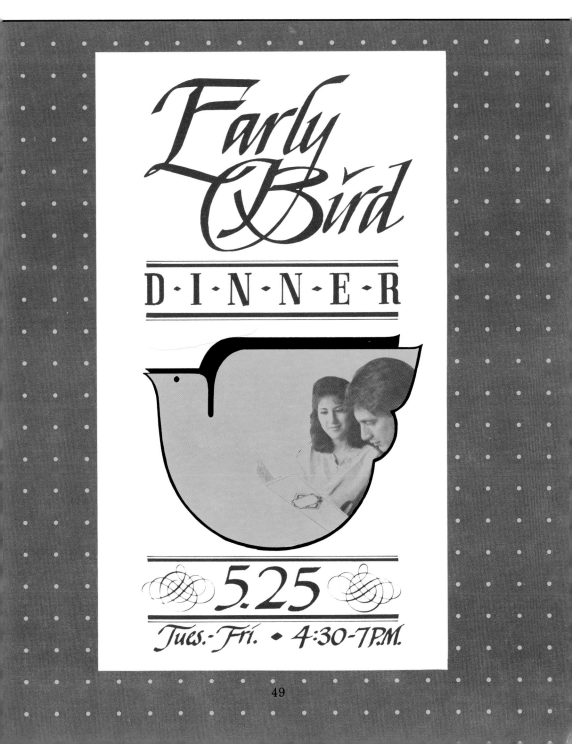

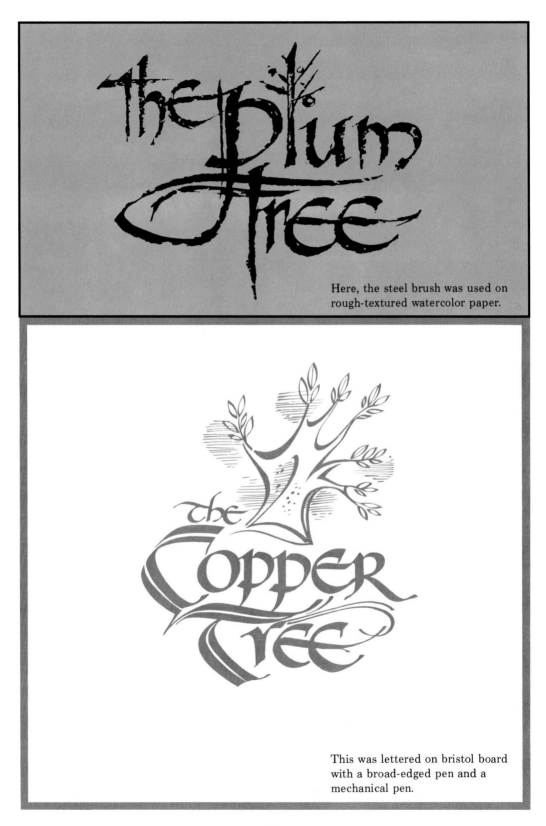

Here, the steel brush was used on rough-textured watercolor paper.

This was lettered on bristol board with a broad-edged pen and a mechanical pen.

Garden Salad with Hickory-Smoked Chicken

A Top of a Mound of Green Groceries,
Tomatoes, Onion, Cucumbers,
Mushrooms and Our Own Special
Dressing

4.25

This is a table tent display for a special
menu item. Its appeal and "sell-ability"
arise from its very existence.

Vintage Calligraphy

Vintage means "of old, recognized and enduring interest, importance or quality." In other words, a classic.

The free-flowing design of the vintage letter-form communicates a life-style, mood, and flavor perfect for enhancing wine and wine-related products.

Hand-lettered wine lists are probably the most popular example of this relationship. Distinctive posters and media advertisements, point of purchase table tents and, of course, wine labels are a few other instances.

The purpose of using vintage calligraphy is to make the reader forget the letters and, instead, capture the inspiration of the mood and the rhythm, a freedom that is the hallmark of a finer hand. This requires practice, trial and error, and stick-to-itiveness.

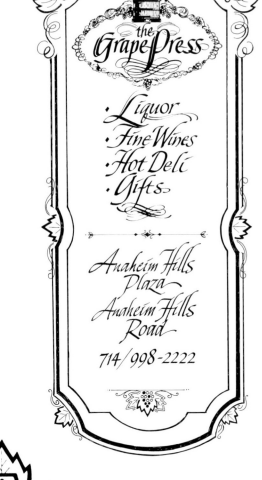

the
Grape Press

• Liquor
• Fine Wines
• Hot Deli
• Gifts

Anaheim Hills
Plaza
Anaheim Hills
Road

714/998-2222

WINES

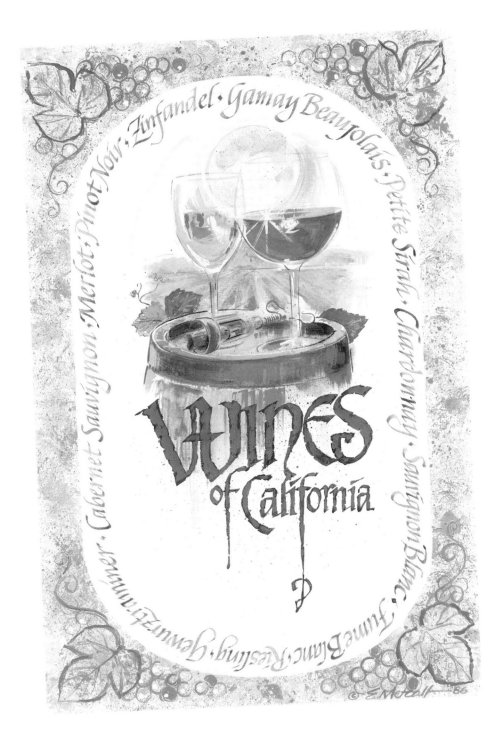

Zinfandel · Gamay Beaujolais · Petite Sirah · Chardonnay · Sauvignon Blanc · Fume Blanc · Riesling · Gewurztraminer · Cabernet Sauvignon · Merlot · Pinot Noir

WINES
of California

© E. Morcott '86

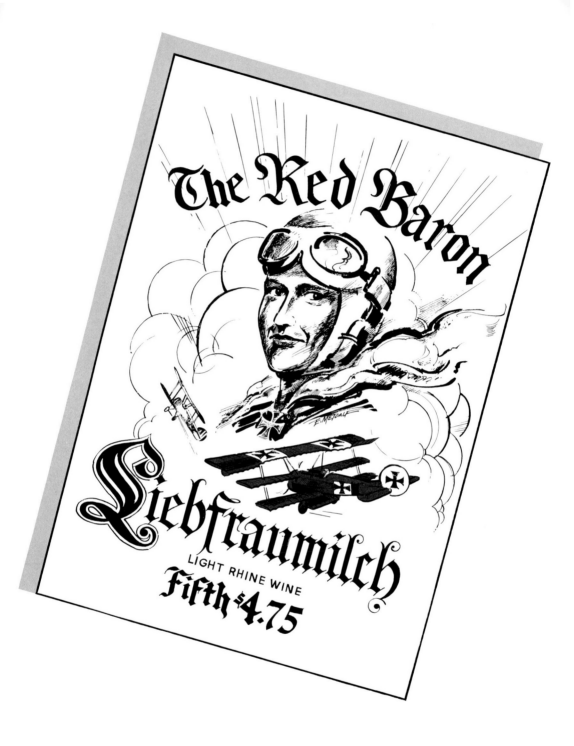

The vintage lettering for this point of
purchase poster depicts the period and
location.

Coats of Arms

A coat of arms is the particular heraldic bearings of a person, usually depicted on a shield. A complete coat of arms consists of a crest, motto and supporters. Coats of arms are widely used commercially to indicate quality, tradition and power, or as a mark of distinction. Note the use of contrasts in the designs below.

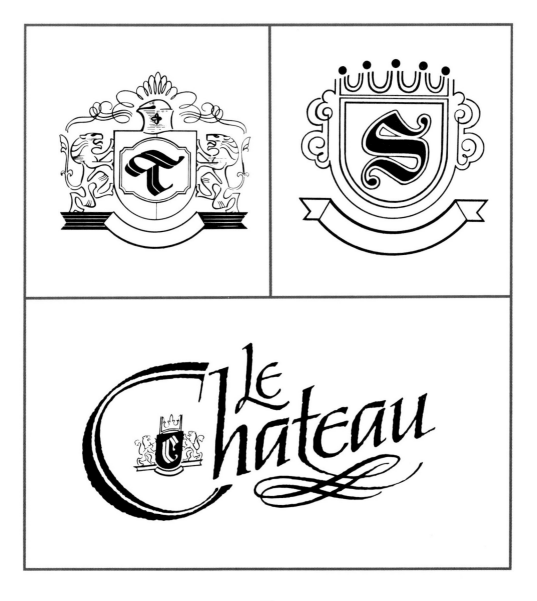

Poetry

Beautiful poetry deserves beautiful writing. Calligraphy can express the thought, feeling and rhyme of the poem. Calligraphic borders and decor can further "dress up" the message.

Trees

I think that I shall never see
A poem lovely as a tree.

A tree whose hungry mouth is prest
Against the earth's sweet flowing breast;

A tree that looks at God all day,
And lifts her leafy arms to pray;

A tree that may in summer wear
A nest of robins in her hair;

Upon whose bosom snow has lain;
Who intimately lives with rain.

Poems are made by fools like me,
But only God can make a tree.

Joyce Kilmer

The use of calligraphy can never be more valuable than to express the mood, color and rhythm of a word such as this. It has international flavor whether in French (as above) or any other language.

headings

A heading is a word or words used for focus, emphasis or decoration. They must demand attention and express a mood. Key words create visual interest through size, color or placement. Headings provide an opportunity to use creativity, design and flourishes.

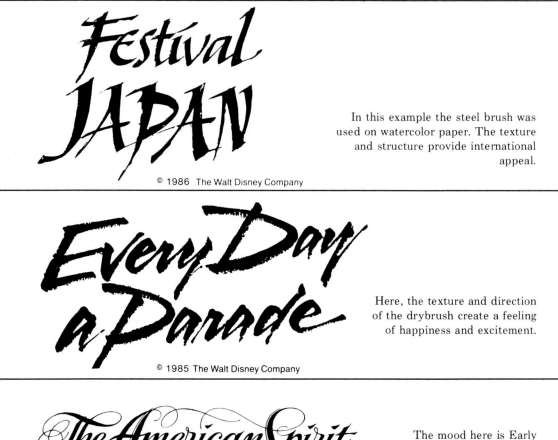

Festival JAPAN

In this example the steel brush was used on watercolor paper. The texture and structure provide international appeal.

© 1986 The Walt Disney Company

Every Day a Parade

Here, the texture and direction of the drybrush create a feeling of happiness and excitement.

© 1985 The Walt Disney Company

The American Spirit at Disneyland

The mood here is Early American, circa 1776. It was first drawn on tissue paper, then traced on illustration board for the final inking. I used a fine-edged pen to achieve the textural effect.

© 1985 The Walt Disney Company

This heading utilizes a bird to express the mood. It was drawn carefully then inked with a fine-point pen.

Here, flourishes are used for a feeling of elegance. It was drawn with a broad-edged pen, then enlarged photographically for the careful, final inking.

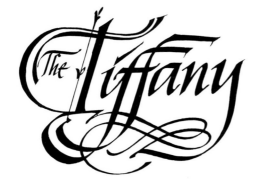

Here, again, flourishes help provide the proper mood.

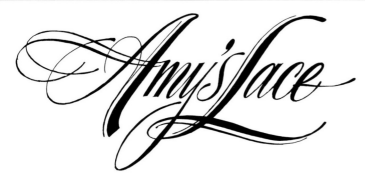

The size and design of this heading attracts the eye and creates visual interest.

Sho-Cards

"All the world is a stage" and our attention can be drawn to it through calligraphic show cards. (A show card is a handlettered placard.) Calligraphy is used when feeling is needed. It can express euphoria, suspense, romance, melancholy, humor, longing, fear and excitement. With the proper use of contrast and design a show card can create interest and captivate its audience.

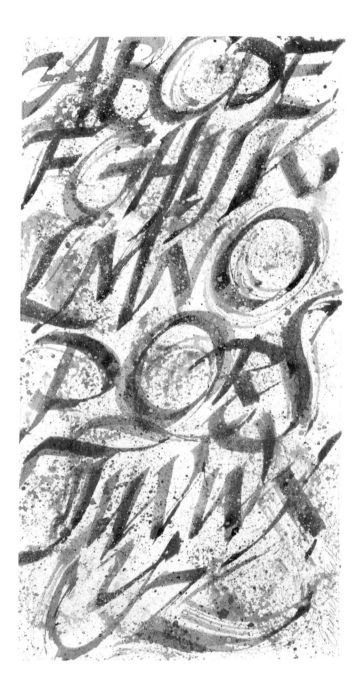

Calligraphy is an artform and makes wonderful graphics for a wall. Experiment with alphabets, words, names, et cetera. Include illustrations, abstract patterns, flourishes, texture and color. It is usually best to use a dip pen, such as a steel brush, because they enable you to change colors for special effects.

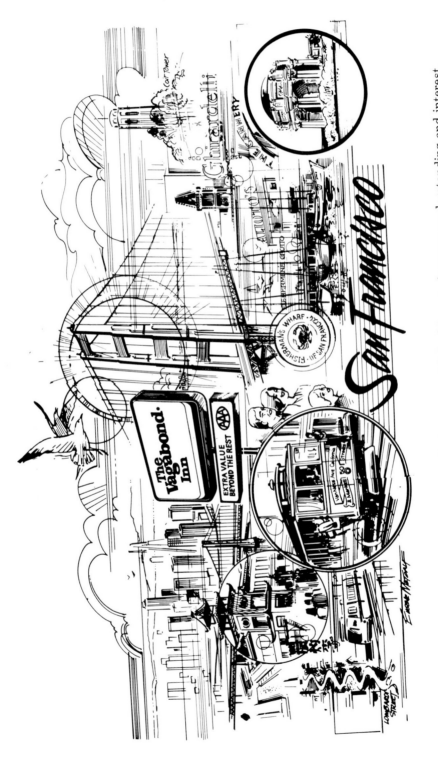

Here, lettering and illustrations are added to an established logo to increase understanding and interest.

In Conclusion

How is your journey thus far? Do you feel the infusion of creativity? Do you have a new interest and motivation for developing your own style of Calligraphy? If so, continue the exciting adventure, fulfill your desire to explore, learn and perfect your skills.

Calligraphy is no longer restricted to stiff, formal, textbook letter styles. It has become an exploratory, do-it-yourself art form that is as varied as the creative abilities of each designer. While it is essential for the serious scribe to be familiar with the basic rules, one should not be confined to them. Creative new approaches are the trend of the day, so let yourself go! Be different, clever and innovative. Develop new designs, new alphabets, new formats, new moods!

If you have any questions or comments, I'd be happy to hear them. You may write to me at 1006 E. Rosewood Avenue, Orange, California 92666. Your attitude may influence the charting of the next course. I treasure your interest and reach for the stars through the art of beautiful writing.....Calligraphy!

ACKNOWLEDGEMENTS

To Lyle Foster for his abundant patience and understanding in making this book possible.

To Sydney Sprague for her suggestions and editing.

To my son, Kevin, for his constant support and encouragement.

To Jeannie, with special appreciation for her tireless, self-sacrificing assistance.

To Annette, for her willing "helping hands."